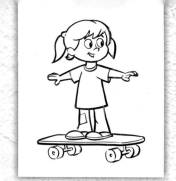

Character Design

Cartooning is about communicating ideas and stories using pictures instead of words, and it's the cartoonist's job to keep the audience interested by creating compelling and memorable characters. In this book, you'll learn how to design characters from start to finish through the use of shapes, lines, expressions, postures, props, and costumes. You'll discover how to create drawings that will tell a reader all he or she needs to know about a character—from personality and emotional state to age and occupation—without the use of words. And whether you draw cartoons as a hobby or as a career (or both!), the lessons in this book will give you a solid foundation in developing unique characters. So pick up a pencil or pen and let's get started! —*Sherm Cohen*

CONTENTS

Getting Started . 2

Shape Up . 4

Head Over Heels . 6

Let's Face It . 8

Mood Swings . 10

Body Building . 12

You Know the Type . 14

Measuring Up . 16

Lights, Camera, Action! . 18

Body Language . 19

Dress 'Em Up . 20

Give 'Em Props . 21

You've Got Males! . 22

Ladies' Night . 23

Kidding Around . 24

Grow Up! . 25

Forget Me Not . 26

Opposites Attract . 27

It's Alive! . 28

Get Graphic . 30

Find Your Own Style . 31

Walter Foster

GETTING STARTED

You don't need much to start designing cartoon characters—just a few pencils, a pad of paper, a couple of erasers, and a pen or marker will do. Chances are you have all you really need right now, but there are a few additional items that can help you make the most out of your cartooning experience. Check out some of the items that I find helpful here; then experiment to see what works for you!

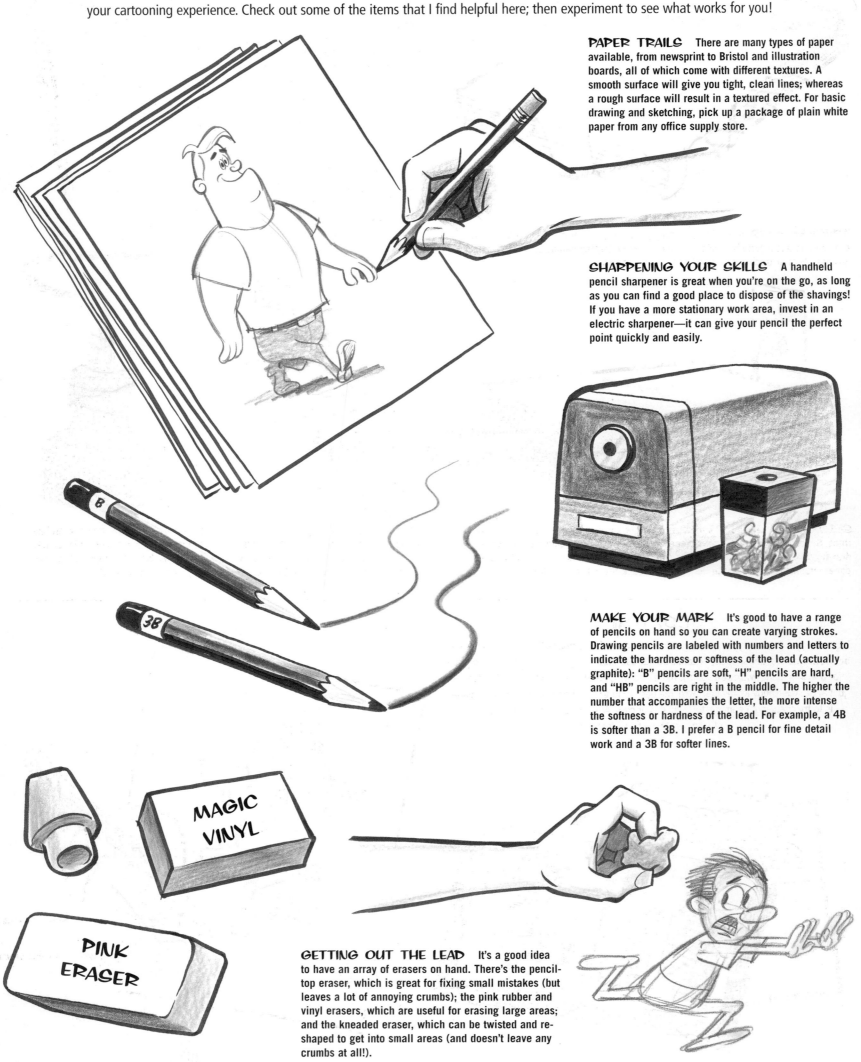

PAPER TRAILS There are many types of paper available, from newsprint to Bristol and illustration boards, all of which come with different textures. A smooth surface will give you tight, clean lines; whereas a rough surface will result in a textured effect. For basic drawing and sketching, pick up a package of plain white paper from any office supply store.

SHARPENING YOUR SKILLS A handheld pencil sharpener is great when you're on the go, as long as you can find a good place to dispose of the shavings! If you have a more stationary work area, invest in an electric sharpener—it can give your pencil the perfect point quickly and easily.

MAKE YOUR MARK It's good to have a range of pencils on hand so you can create varying strokes. Drawing pencils are labeled with numbers and letters to indicate the hardness or softness of the lead (actually graphite): "B" pencils are soft, "H" pencils are hard, and "HB" pencils are right in the middle. The higher the number that accompanies the letter, the more intense the softness or hardness of the lead. For example, a 4B is softer than a 3B. I prefer a B pencil for fine detail work and a 3B for softer lines.

MAGIC VINYL

PINK ERASER

GETTING OUT THE LEAD It's a good idea to have an array of erasers on hand. There's the pencil-top eraser, which is great for fixing small mistakes (but leaves a lot of annoying crumbs); the pink rubber and vinyl erasers, which are useful for erasing large areas; and the kneaded eraser, which can be twisted and re-shaped to get into small areas (and doesn't leave any crumbs at all!).

TOUCHING UP You may want to try out a few different types of drawing tools for a cleaned-up, professional look; for example, there are colored pencils, markers, brush pens, and watercolor brushes. Brush pens give you the gorgeous line of a brush without having to keep dipping them in ink! And watercolor brushes will also produce a sleek look; the most common brush sizes range from #0 (very fine tip) to #4 (very fat tip), but most "ink slingers" use a #2 brush. (Make sure to keep the brush clean, and never dip the metal part into the ink.)

TRACING YOUR STEPS Tracing paper is great for experimenting with a character to get it just right. Sketch a character on tracing paper; then slip it under another sheet of tracing paper and make some adjustments.

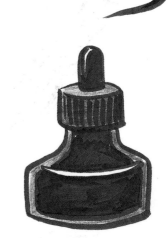

SEEING THE LIGHT A professional light box can help you produce clean lines. Sketch your character on a piece of tracing paper, and then tape the finished drawing to the surface of the light box with artist's tape. Then place a piece of heavier paper over the sketch, turn on the light, and trace the drawing with ink. Ta-da!

COVERING UP If you make a mistake, try some correction fluid; it's often so discreet that no one will be able to tell where you've made a blooper.

INKING IT For dramatic outlines, dip the tip of a watercolor brush into India ink. Just be careful not to drip any on your drawings!

COPYCAT

A good way to improve your drawing skills is to copy other cartoons that catch your eye in books, magazines, newspapers, or comic books. Use these images as a reference and practice drawing them (without tracing!). There's nothing wrong with copying for practice—just about everybody learns that way! The best thing to do when copying another image is to try changing the image to make it your own: Alter the pose or the expression, or exaggerate the facial features.

SHAPE UP

Anyone can learn to design cartoon characters by simply remembering the three most basic shapes: the circle, the square, and the triangle. All subjects can be broken down into variations of these three shapes—and once you give *form*, or dimension, to those shapes, you'll have objects that seem to bounce right off the page. Try combining different shapes to see what new forms you can create!

TAKING SHAPE The triangle, the circle, and the square are the basic building blocks of all cartoon drawings. Combine variations of these three shapes to design and give life to your creations!

CREATING 3-D FORMS

The first thing we need to do with the three basic shapes is to think of them as forms: real objects in three dimensions, with solidity, depth, and weight. If you treat these shapes as real forms in space, the drawings you make from them will also have the appearance of being real. This is a basic example of using *perspective,* or the representation of objects in three-dimensional space.

In addition to using the rules of perspective, shading your objects with varying values—from black through various grays to white—will give the shape form, or the appearance of three dimensions. (Imagine the shapes you draw as objects that can be lifted off the page and carried away!)

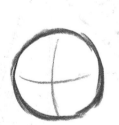 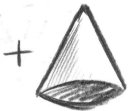

Triangle shape becomes cone form

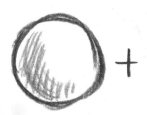

Circle shape becomes sphere form

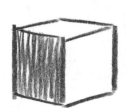 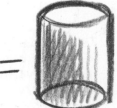

Square shape becomes cube form

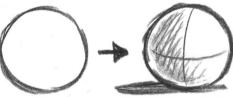 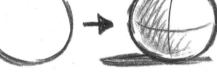

Sphere + cone = teardrop

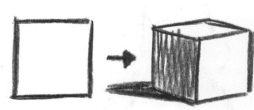

Sphere + cube = cylinder

ADDING IT UP

You can create numerous forms by combining two or more shapes. Here two spheres can make a bean, pear, pickle, or egg shape!

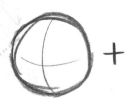 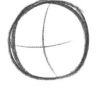 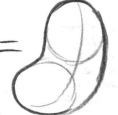 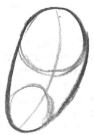 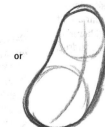

PUTTING IT ALL TOGETHER

The four most-used shapes in designing cartoon characters are the sphere (or ball or egg shape), the teardrop, the bean (or pear shape), and the cylinder. Create a head, hands, and feet out of a sphere; construct a torso with the teardrop or the bean shape; and fashion legs and arms using cylinders. Drawing cartoon characters is a little like building your own Frankenstein—you can collect different parts and build on them to make a whole!

Sphere

Teardrop

Bean

Cylinder

STEP 1 To draw this little darling, start with a ball-shaped head and a bean-shaped body. Use tapered cylinders for the arms and legs, and create ball shapes for the hands and feet. The guidelines help establish the pose and will help you place the features.

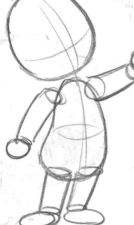

STEP 2 Once the basic forms are drawn, add the hair, face, clothing, and hands. Notice how these features are wrapped around the forms of her body. For example, the waistline of her dress follows the form of her bean-shaped body, and the tops of her socks follow the roundness of her cylindrical legs.

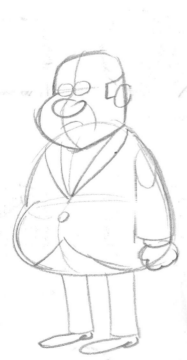

STEP 3 After gently erasing your guidelines with a kneaded eraser, you can clean up the drawing by going over the lines you want to keep with a pencil.

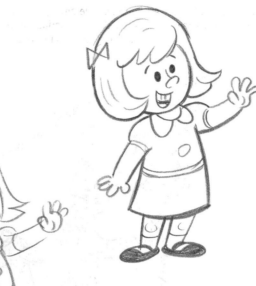

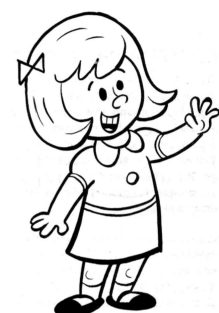

STEP 4 Or you can clean up your drawing with ink for a slick finish!

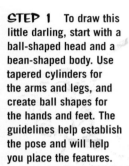

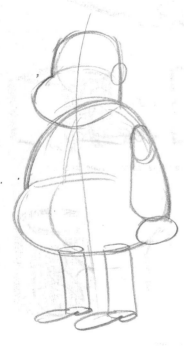

STEP 1 To draw this grumpy guy, start with a bean-shaped head and an egg-shaped ear. Then add a bigger bean shape for the body. Create a long teardrop shape for the sleeve and a ball for the hand. Use cylinders that taper at the ends for legs and sideways teardrop shapes for feet.

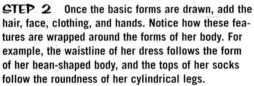

STEP 2 Draw a light guideline down the middle of the face, and then add a sideways teardrop shape for the nose. Rough in the rest of the face, and start to add the clothing around his portly form. Notice the way the jacket seems to wrap around his body, and the center of the jacket lines up with the guidelines!

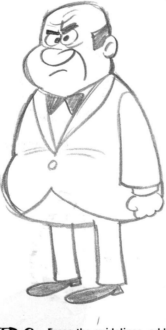

STEP 3 Erase the guidelines, add some final details, and he's ready to have a grumbly day!

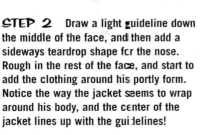

STEP 4 Or give him the brush-and-ink treatment to add more impact!

HEAD OVER HEELS

Where's the best place to begin? At the beginning, of course! And the beginning of the body is the head. Think of the head as a rounded mass that can take on many different shapes: A head can be shaped like a ball, an egg, a teardrop, a pear, a bean, or even a triangle. Practice drawing different head shapes in a variety of poses and angles; then determine which one best suits your cartoon character!

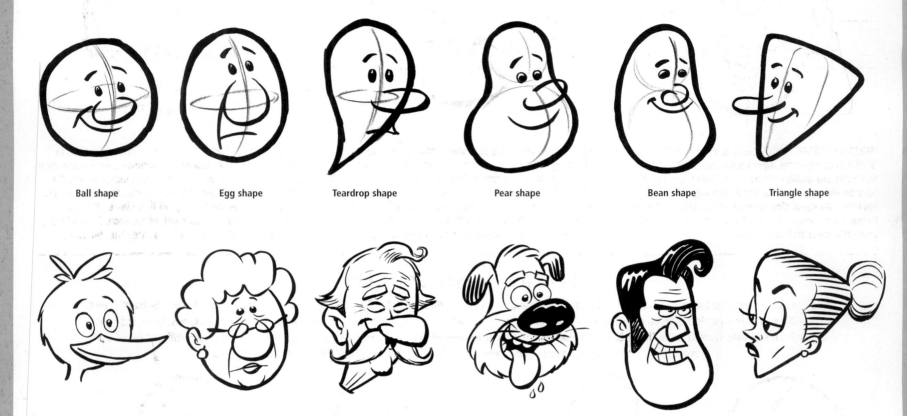

Ball shape **Egg shape** **Teardrop shape** **Pear shape** **Bean shape** **Triangle shape**

BUILDING ON FOUNDATIONS

The six generic head shapes are the foundation for the six character heads above. A ball shape becomes a cute bird, an egg shape produces a sweet old lady, an upside-down teardrop shape transforms into somebody's grandpa, a pear shape morphs into a slobbery pooch, a bean shape creates a tough-guy Elvis impersonator, and a triangle shape makes a stylish model.

PLAYING WITH SHAPES

You can stretch, squash, and combine different shapes to create an endless variety of cartoon heads! Take a look at the heads below and see if you can "look through" them to find their underlying building-block shapes.

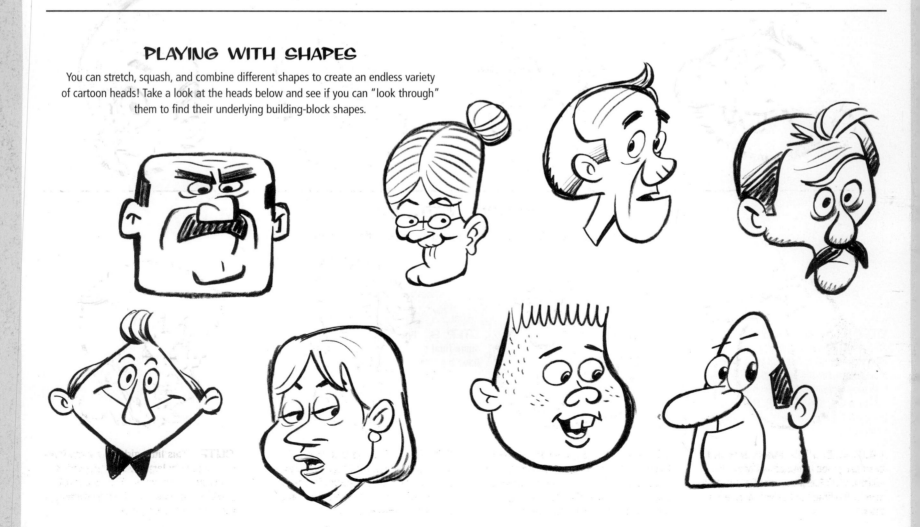

CARTOON PROPORTIONS

Before you develop the eyes, nose, ears, and mouth, you should have a basic understanding of an average cartoon's facial *proportions* (the size relationship among the parts).

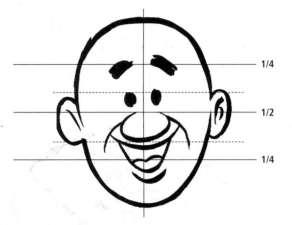

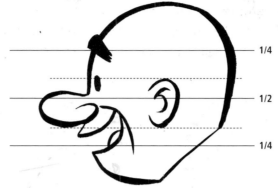

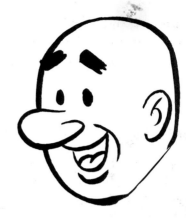

FRONT VIEW The top of the nose is halfway down the face, the eyes are right above the nose, and the eyebrows are about halfway up the forehead. Plant the ears on either side of the head, and align the tops of the ears with the eyes. The bottoms of the ears usually fall below the bottom of the nose, and the mouth is halfway down the lower half of the head.

SIDE VIEW The side view of the head is also called the "profile." Note that the proportions of the face stay the same no matter which direction the head is turned. By lightly drawing guidelines on every head you draw, you can make sure that the features of the face stay in the same place from drawing to drawing. See "Placing Facial Features" below for more on drawing guidelines.

THREE-QUARTER VIEW This angle falls in between the front view and the profile, and it is the most versatile view. In most cartoons and comic strips, the characters are drawn in the three-quarter view because cartoons rarely look straight at the viewer, but the profile view cuts off too much of the face. Most of the examples in this book will be a three-quarter view.

PLACING FACIAL FEATURES

Using the four common head shapes below, draw guidelines horizontally and vertically. These guidelines will help you correctly and consistently plant the features on the face. The vertical line should always go right down the center of the face, but the horizontal guideline can be placed anywhere you want the nose to be. The point at which the two lines intersect is the "home base" from which all the facial features emerge. Here I've drawn the exact same features on four different face shapes, creating four entirely different looks! Notice how all the faces are built up around the sketched-in guidelines.

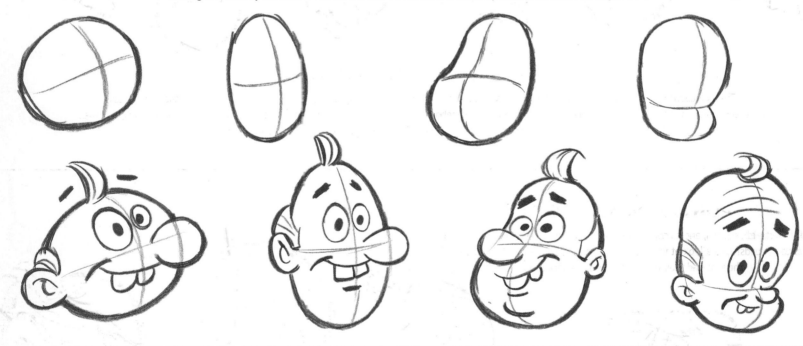

SHIFTING FEATURES

You can move features around on the head to achieve different effects.

WORRIED This fellow's eyes and nose are placed high on his head. He looks a little funny because he seems to have a tiny brain and a low, perplexed mouth.

TOUGH This guy also has a small forehead, but he's got a big, meaty face to go with it. These combined features give him the look of a real tough guy who has more brawn than brains.

BRAINY This egghead type is the exact opposite of the tough guy sitting next to him. His extra-large forehead and weak chin give him the look of a scientist or professor.

CUTE This little girl has a large forehead and very large eyes in proportion to her nose and mouth. This is a great combination when you want to capture that "cute little kid" look.

LET'S FACE IT

Cartoon faces are the most important element of character design, as the features that make up that face convey your character's personality! For example, heavy-lidded eyes; a weak chin; goofy, protruding ears; and a wide, toothy smile are all telling signs of a character's mood and manner. Practice drawing variations of each feature—draw tall eyes and small eyes, round ears and pointy ears, thin lips and fat lips, bulbous noses and broken noses. And don't forget to accessorize!

ALL EYES HERE Cartoon eyes can take many different shapes—they can be tall, small, wide, skinny, open, closed, asymmetrical, bugged-out, or even just a couple of dots! Highlights can be drawn with squares or rectangles, or not at all. And don't forget about the eyebrows—from bushy and thin to straight and curved, the shape and size of eyebrows tell a lot about your character's attitude!

EYE VARIATIONS

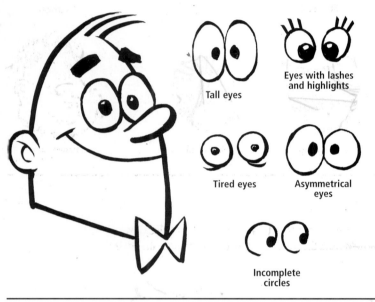

Tall eyes

Eyes with lashes and highlights

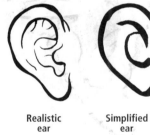
Tired eyes

Asymmetrical eyes

Incomplete circles

DOTS

Dots with curved highlights

Tall dots

Tall dots with wedge-shaped highlights

SEMICIRCLES

Happy eyes

Closed eyes

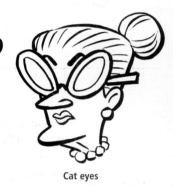

GLASSES

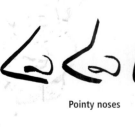
Black rimmed

Shades

Cat eyes

LISTEN UP A natural, realistic-looking ear has no place in the cartoon world—ears need to be broken down and simplified. A baby's ear should be small and uncomplicated to keep the baby young and cute, whereas an adult's ear should be larger and more detailed (and sometimes even sprouting hair!). Use crumpled ears for a "tough" type, pointy ears for aliens or elves, and accessorized ears for females.

EAR VARIATIONS

Realistic ear

Simplified ear

More simplified ear

Most simplified ear

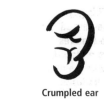
Simplified ear variations

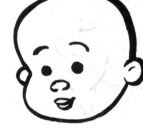
Baby's ears

Grandpa's ear

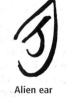
Crumpled ear

Alien ear

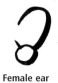
Female ear

THE NOSE KNOWS Drawing a distinctive nose is one of the best ways to make a character stand out from the crowd. And when it comes to cartoon noses, bigger is often better! Experiment with several different kinds of noses—try drawing them from the front as well as in profile. You'll get the hang of it!

NOSE VARIATIONS

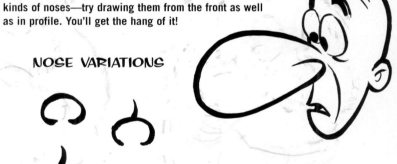

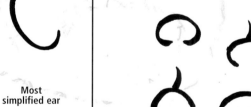
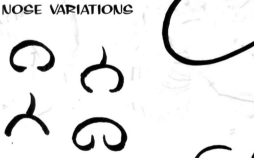
Small noses

Round noses

Pointy noses

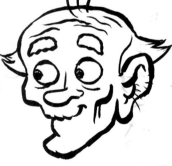
Pickle-shaped noses

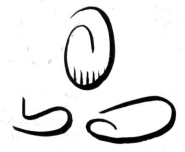

Broken noses

MUG SHOTS The mouth and chin are also important elements of a cartoon character. A mouth can be frowning, smiling, opening wide in shock or surprise, sneering, or even spitting in anger! An *exterior mouth* is drawn along the edge of the face, whereas an *interior mouth* is drawn completely within the boundaries of the face. A distinctive chin is sure to add personality to your character—try drawing a chin that juts out, one that tucks in, or one that's double-wide!

CHIN VARIATIONS

Underbite

Overbite

Double chin

EXTERIOR MOUTHS

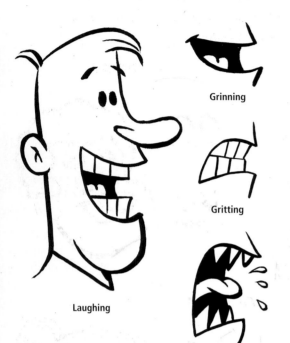

Grinning

Gritting

Laughing

Screaming

INTERIOR MOUTHS

Grinning

Smiling

Shocked

Angry

Smiling widely

Laughing

Surprised

MIX AND MATCH

The key to cartoon faces is combining the right facial features to accurately portray the type of character you want to depict. The eyes, nose, mouth, and ears should each contribute to the overall effect you're trying to achieve. And the more exaggerated the features, the better!

YES!

NO

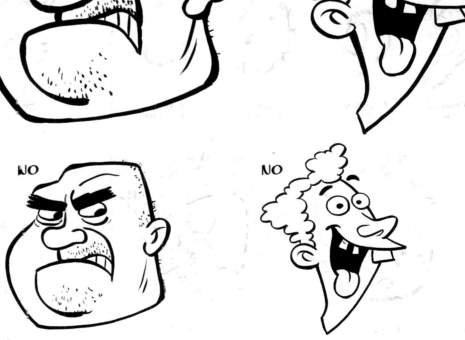

YES!

YES!

NO

NO

THE CUTE TYPE With her simple features, this character has a "girl next door" appeal. But if we give her an overbite instead of a small mouth, she won't look so cute. Too much detail on her ears takes away the focus from her wide eyes and pretty smile.

THE TOUGH TYPE This dude's rough, lumpy features all work together to convince us that he's a real bruiser. But trading in his crooked, broken nose for a smaller one and his large, crumpled ear for a classic one takes away from that tough-guy look.

THE GOOFY TYPE This guy has wild, googly eyes, a pickle-shaped nose, and a silly mouth. These features combine to make him look like a class-A goofball! But if his eyes and nose are less exaggerated and smaller, he loses some of that clownish quality.

MOOD SWINGS

To draw believable expressions and attitudes, try studying your own face in a mirror to see how your features change as you portray a variety of moods—then record what you see. The six faces below are the foundation for creating every expression you could ever imagine! The face in the middle is the "flat" face—blank and expressionless, it acts as the canvas upon which all other emotions are created. Circling this face are the five most common expressions that can be created simply by making adjustments to the foundation.

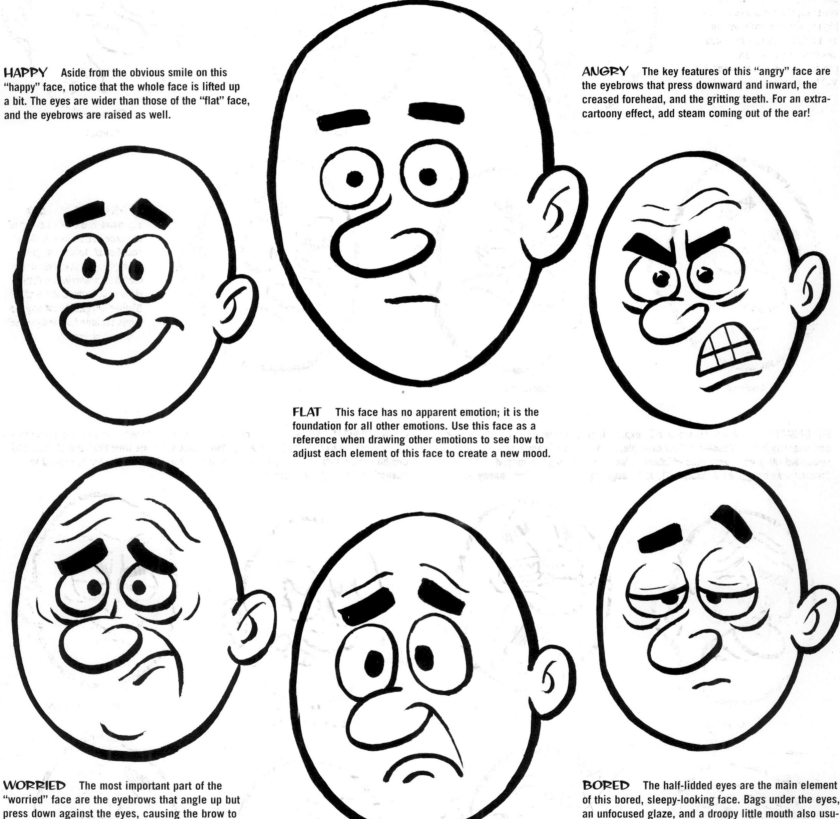

HAPPY Aside from the obvious smile on this "happy" face, notice that the whole face is lifted up a bit. The eyes are wider than those of the "flat" face, and the eyebrows are raised as well.

ANGRY The key features of this "angry" face are the eyebrows that press downward and inward, the creased forehead, and the gritting teeth. For an extra-cartoony effect, add steam coming out of the ear!

FLAT This face has no apparent emotion; it is the foundation for all other emotions. Use this face as a reference when drawing other emotions to see how to adjust each element of this face to create a new mood.

WORRIED The most important part of the "worried" face are the eyebrows that angle up but press down against the eyes, causing the brow to crease with "worry lines." The worried face often has bags or dark circles under the eyes, and there's usually a pathetic little frown to boot.

SAD This expression can look a lot like "worried," but the main distinction is the long frown. The eyebrows are raised and tilted inward, but they don't press against the eyes as they do on a "worried" face. Keep in mind that the pupils are larger and longer on a sad face.

BORED The half-lidded eyes are the main element of this bored, sleepy-looking face. Bags under the eyes, an unfocused glaze, and a droopy little mouth also usually accompany a "bored" face. Surprisingly, this face is the starting point for many other useful expressions, such as "drunk" and "impatient."

VARIATIONS ON A THEME

There are four essential methods you can use to create additional emotions from the six basic moods: asymmetry, amplification, intensity, and combination. By using these four techniques, you can make your cartoon characters convey any emotion under the sun!

AMPLIFICATION

To *amplify* an expression, take a basic feature and make it larger and wider. In "surprised," the eyes from the "happy" face have been widened, the eyebrows raised higher, and the smile turned up a notch. You can also use this technique to create expressions like "shocked" and "startled."

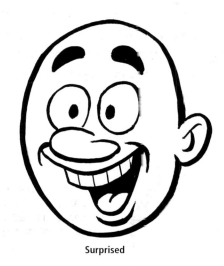

Surprised

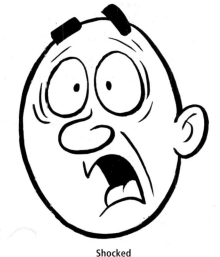

Shocked

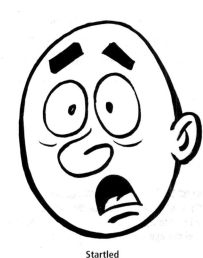

Startled

Confused

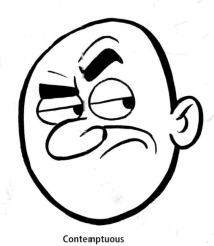

Contemptuous

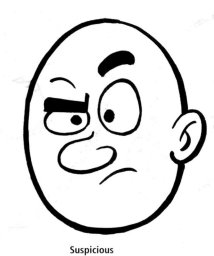

Suspicious

ASYMMETRY

With *asymmetry*, the two halves of the face are different. The "confused" face is a good example: The left side of the face looks worried, but the right side looks a little sad. Similar asymmetrical expressions include "contemptuous" and "suspicious."

INTENSITY

To get a more dramatic expression, take one of the basic emotions and intensify it. For "desperate," for example, take the "sad" face and make it even more sad! Other good examples of intensity include "yawning" (a magnified "bored"), "scared" (an exaggerated "worried"), and "laughing" (an intensified "happy").

COMBINATION

When you combine two or more different moods, the result is a whole new emotion! To get a "sneaky" look, take the eyes from the "angry" face and combine them with the smile from the "happy" face. Other examples are found in "impatient," "evil," and "drunk."

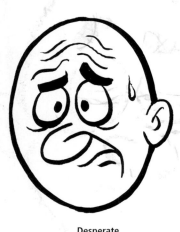

Desperate

Yawning

Scared

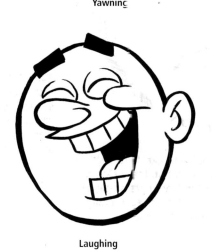

Laughing

Angry + happy = sneaky

Angry + really happy = evil

Angry + bored = impatient

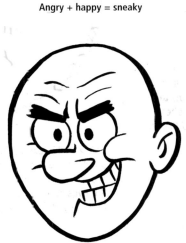

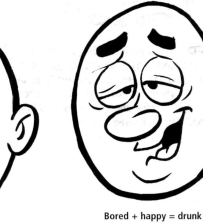

Bored + happy = drunk

BODY BUILDING

Now that you've perfected the art of making your cartoon characters laugh, cry, and take a snooze, you can start designing the rest of the body. After all, your head needs a torso—not to mention arms, legs, feet, and hands! A good character drawing should look like a living, breathing person—not just a bunch of lines on a piece of paper. So take what you've learned about using basic shapes to build bodies and heads, and put them together to create the perfect cartoon character.

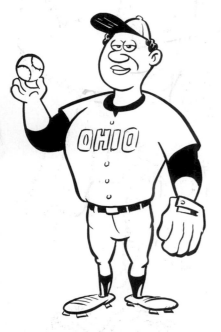

SIMPLIFYING THE STRUCTURE
This baseball player is a solid-looking guy—there's a firm structure underneath the finished drawing.

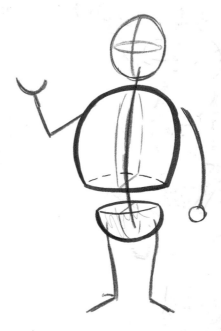

A character's structure is based on the skeleton that supports the entire body. But we don't need to start out with anything as complicated as this . . .

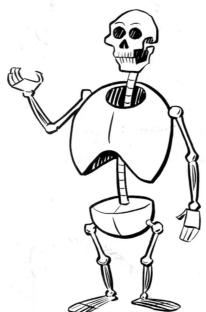

. . . just simplify the skeleton into very basic shapes that indicate the rib cage, the pelvis, and the spine.

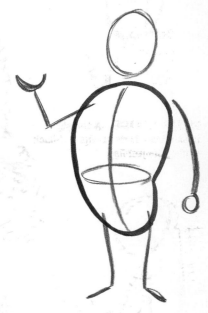

Then simplify the skeleton even further by combining the ribs and the pelvis into one beanlike shape!

BEAN ME UP, SCOTTY

The same bean shape that you saw earlier when constructing heads can also be used when creating bodies. And it can take on many different forms. Try turning it upside down, making it wider on the bottom and narrower at the top, or scrunching it up.

TOP HEAVY
By making your bean-shaped body wider at the top, you can create a curvy character with attitude.

FLAT BOTTOM
This simple little guy has a flat bottom on his bean-shaped body. Play around with these shapes to create new forms!

NO NECK Some characters' heads run into their body shapes. Try using the bean shape for both the head and the torso to get a "vertically challenged" look.

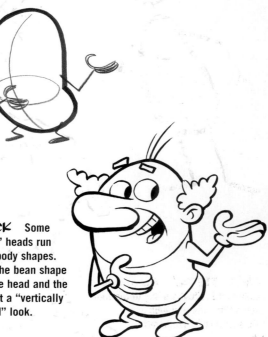

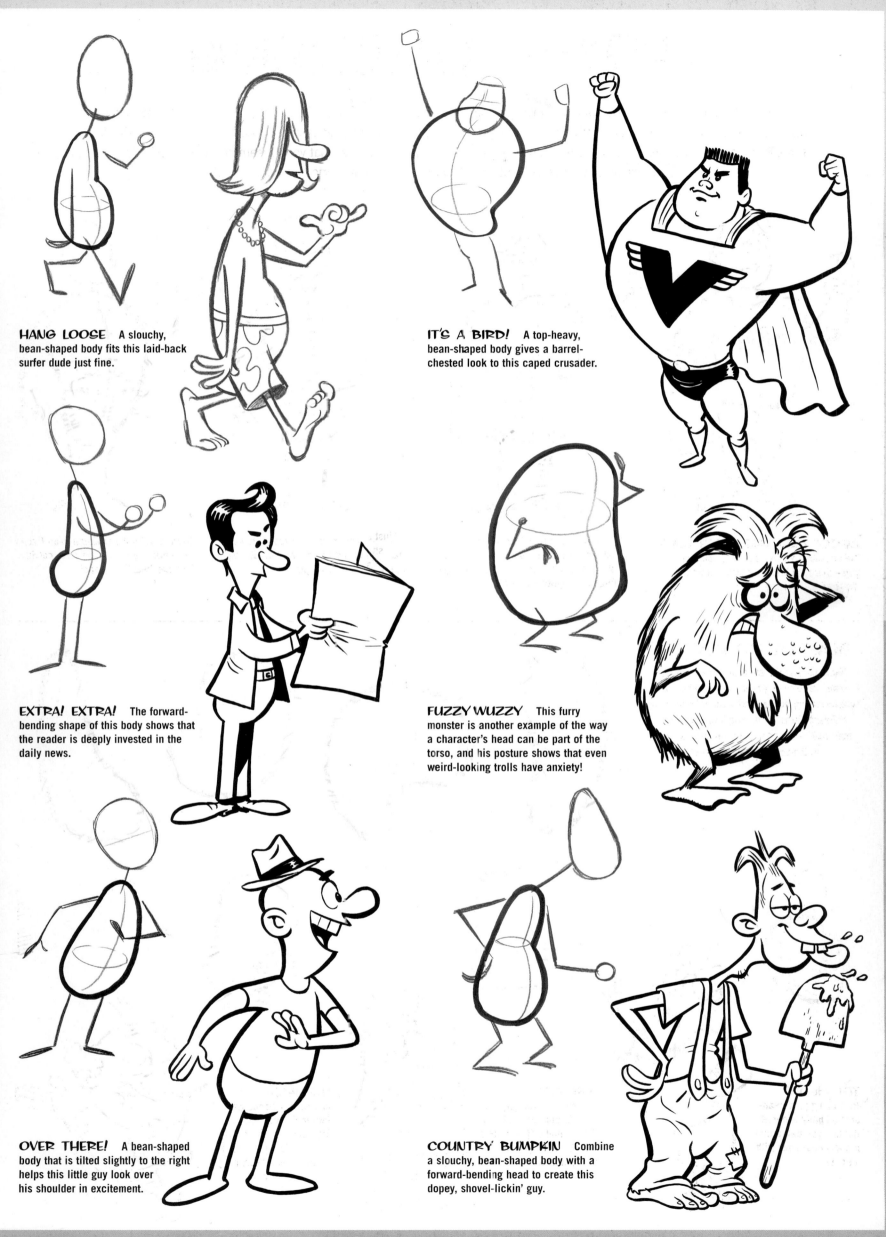

HANG LOOSE A slouchy, bean-shaped body fits this laid-back surfer dude just fine.

IT'S A BIRD! A top-heavy, bean-shaped body gives a barrel-chested look to this caped crusader.

EXTRA! EXTRA! The forward-bending shape of this body shows that the reader is deeply invested in the daily news.

FUZZY WUZZY This furry monster is another example of the way a character's head can be part of the torso, and his posture shows that even weird-looking trolls have anxiety!

OVER THERE! A bean-shaped body that is tilted slightly to the right helps this little guy look over his shoulder in excitement.

COUNTRY BUMPKIN Combine a slouchy, bean-shaped body with a forward-bending head to create this dopey, shovel-lickin' guy.

YOU KNOW THE TYPE

Just as there are different types of people, there are certainly different types of cartoon characters! There's the "cute" type, the "tough" type, the "dumpy" type, the "goofy" type, and so on. And each character type is made up of certain elements that suggest a specific personality—for example, the "dumpy" type has a rounded, bulbous body, and the "tough" type takes on a top-heavy bean shape. Think about what personality you want your character to have, and then create a body type that goes with it.

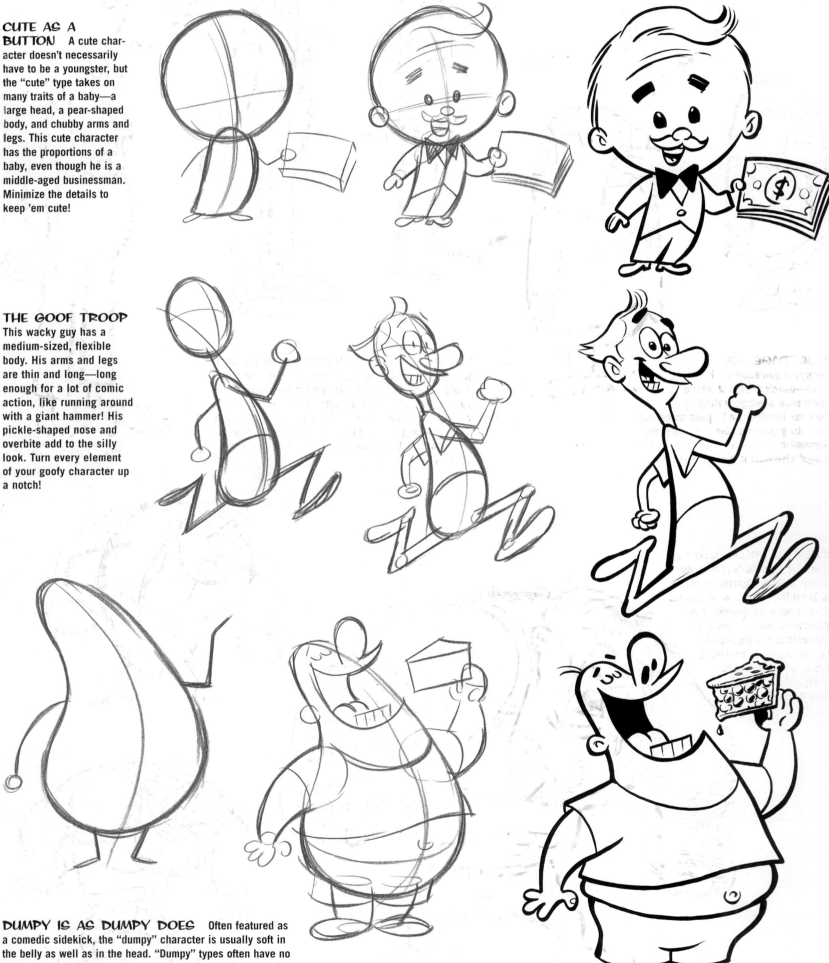

CUTE AS A BUTTON A cute character doesn't necessarily have to be a youngster, but the "cute" type takes on many traits of a baby—a large head, a pear-shaped body, and chubby arms and legs. This cute character has the proportions of a baby, even though he is a middle-aged businessman. Minimize the details to keep 'em cute!

THE GOOF TROOP This wacky guy has a medium-sized, flexible body. His arms and legs are thin and long—long enough for a lot of comic action, like running around with a giant hammer! His pickle-shaped nose and overbite add to the silly look. Turn every element of your goofy character up a notch!

DUMPY IS AS DUMPY DOES Often featured as a comedic sidekick, the "dumpy" character is usually soft in the belly as well as in the head. "Dumpy" types often have no neck at all—their bottom-heavy, pear-shaped bodies flow right into their small heads. Notice the way this character's belly hangs out of his shirt because he can't find shirts in his size.

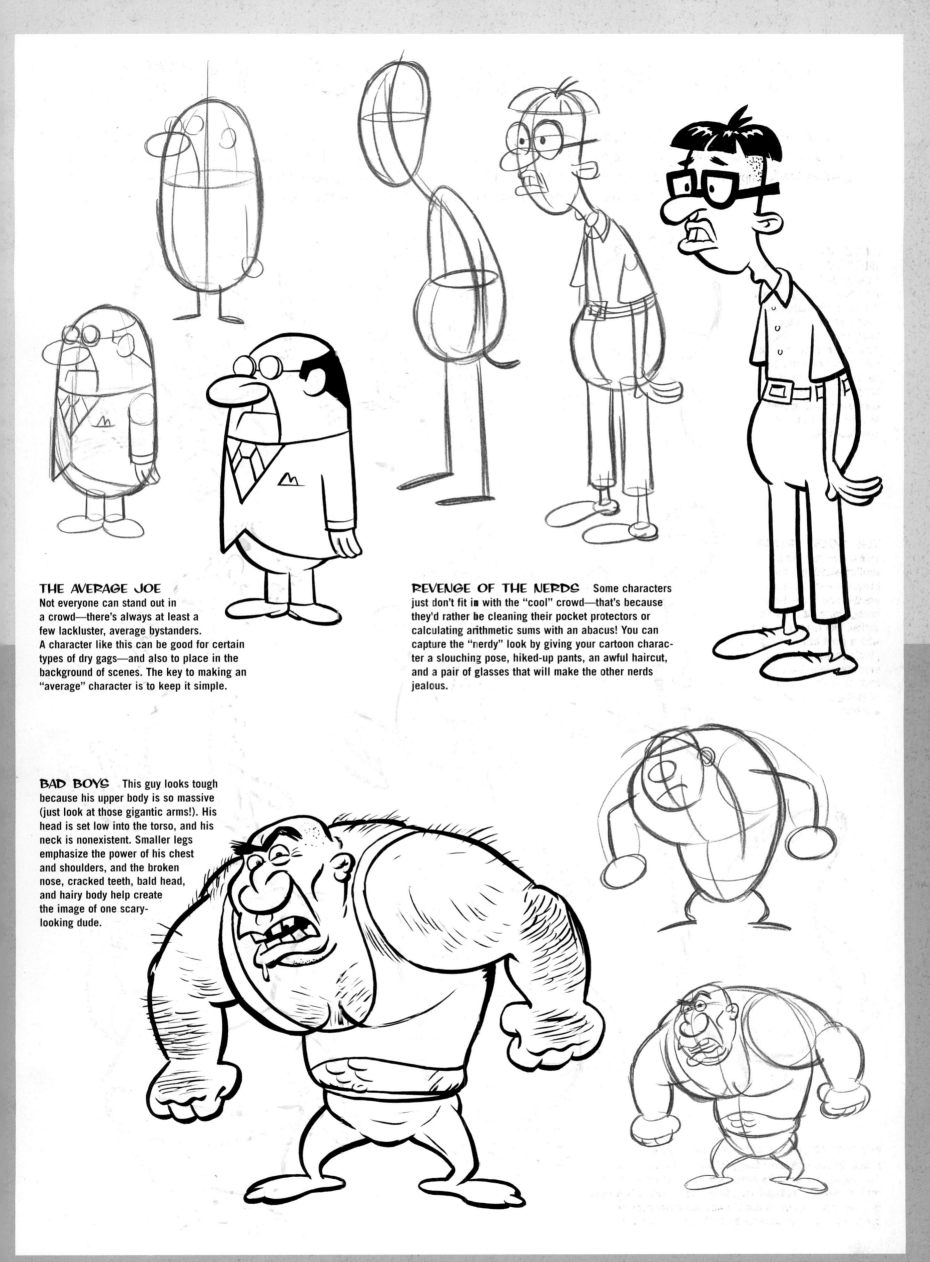

THE AVERAGE JOE

Not everyone can stand out in a crowd—there's always at least a few lackluster, average bystanders. A character like this can be good for certain types of dry gags—and also to place in the background of scenes. The key to making an "average" character is to keep it simple.

REVENGE OF THE NERDS

Some characters just don't fit in with the "cool" crowd—that's because they'd rather be cleaning their pocket protectors or calculating arithmetic sums with an abacus! You can capture the "nerdy" look by giving your cartoon character a slouching pose, hiked-up pants, an awful haircut, and a pair of glasses that will make the other nerds jealous.

BAD BOYS

This guy looks tough because his upper body is so massive (just look at those gigantic arms!). His head is set low into the torso, and his neck is nonexistent. Smaller legs emphasize the power of his chest and shoulders, and the broken nose, cracked teeth, bald head, and hairy body help create the image of one scary-looking dude.

MEASURING UP

To make your characters measure up—literally—you need to figure out the correct proportions. In cartooning, a character's body is sized in relation to its head, which is the standard unit by which characters are measured. Characters look cute and young if they're 3 (or fewer) heads tall. Conversely a character that is more than 5 heads tall looks grown up and more mature. The average adult character is 5 or 6 heads tall, but exaggerated characters like superheroes and glamorous fashion models can be 8 or more heads tall.

HEAD TO HEAD
These two figures are exactly the same height but have different proportions. The fellow to the left stands 3 heads tall, whereas the guy on the right is 4 heads tall. Although they are the same height, the heads by which they are measured are different sizes.

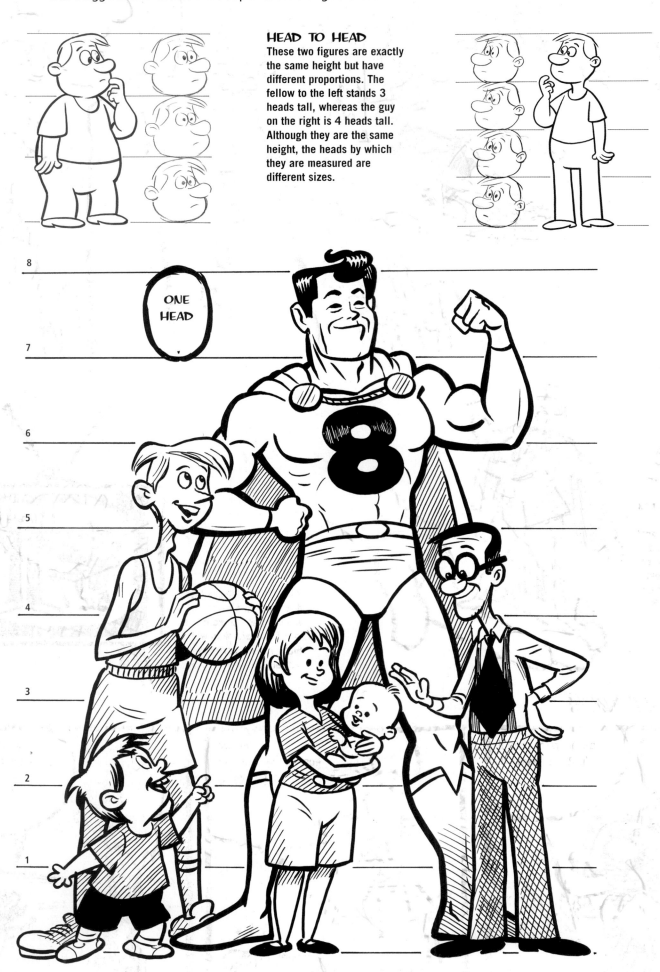

LINING UP Above you can see an entire range of proportions. Each line represents one head, with the heads all being the same size (except for the baby's). The toddler is 2-1/2 heads tall—a very common proportion for little kids and cute critters.

Mom is 4 heads tall, and the baby is just 2 heads tall. Dad stands at 5 heads tall, which is about average for most adult cartoons. Their hoop-shooting teenage son is a gangly 6 heads tall, and the superhero-next-door stands heroically at 8 heads tall.

ATTACK OF THE 80-FOOT BABY

When designing characters, it's important to remember that although proportion is related to height, they are not the same thing. This baby must be enormously tall to swat airplanes out of the sky atop the Empire State Building! Even though the rest of the image tells us that this figure is huge, his proportion (he's about 2 heads tall) tells us that he's still an adorable little baby.

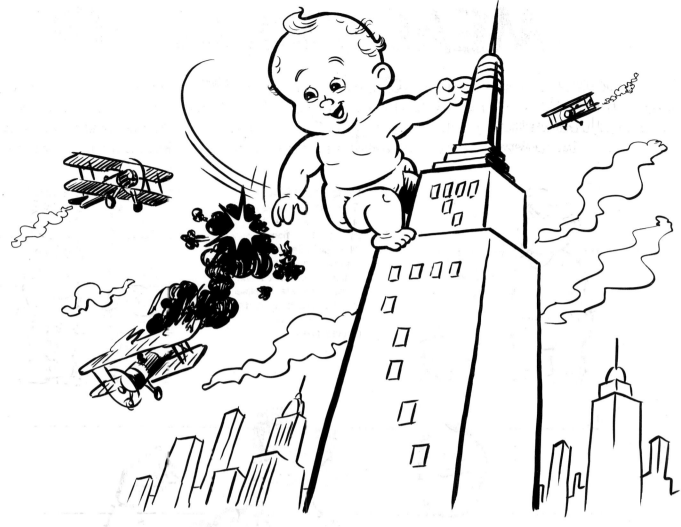

SHRINKING SUPERHEROES

Judging by his teensy size, it looks like our super friend must have fallen into the ray of some evil villain's shrink gun. But, even though he's so small in size that he can fit into the palm of a hand, it's clear that he hasn't lost his super status—he still has that heroic proportion of 8 heads tall.

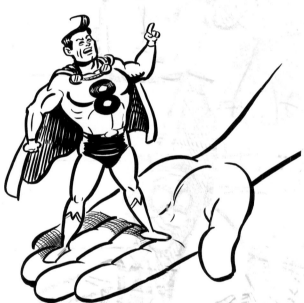

TV TIME Characters that are 2 to 4 heads tall will fit better in the frame of a TV screen than will those lankier cartoons that are 6 to 8 heads tall.

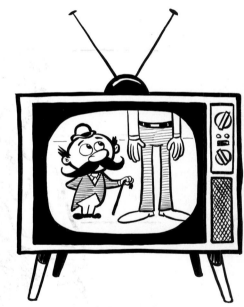

PROPORTION FUNNIES

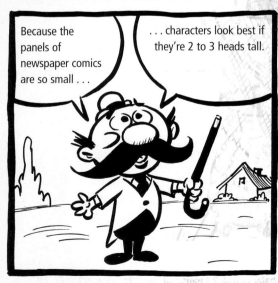

Because the panels of newspaper comics are so small . . .

. . . characters look best if they're 2 to 3 heads tall.

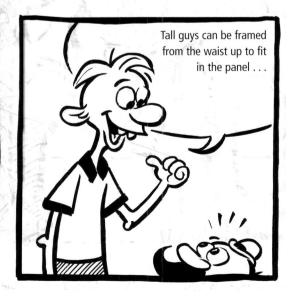

Tall guys can be framed from the waist up to fit in the panel . . .

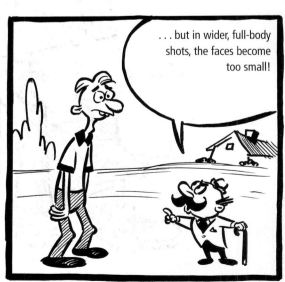

. . . but in wider, full-body shots, the faces become too small!

FRAMING THE FUNNIES When drawing cartoons for newspaper comics, it's best to make small characters 2 to 3 heads tall. If you're featuring a tall character, draw him from the waist up and place him closer to the front of the frame; setting him back in the frame to render the whole body will make him appear too distant.

LIGHTS, CAMERA, ACTION!

Cartoon characters come to life through acting—and acting, at its core, means movement. This is why the *line of action* (an imaginary line that extends through a figure and indicates the curve of its movement) is one of the most important factors in bringing your characters to life on paper. All living things move around in one way or another, and even plants and animals tend to have a bend or curve to their movement. In most characters, the line of action starts at the head, travels down the spine, and flows out at either the hands or the feet.

LACKING ACTION

This little guy is looking up at something exciting in the sky, but his body isn't showing any emotion or movement at all. In fact, this pose looks downright boring and stiff!

NO

PACKING ACTION

But if he arches his back, lifts up his head, and thrusts out his arm, we can tell that he's really excited! If your characters display strong emotions, your audience will feel the emotions too.

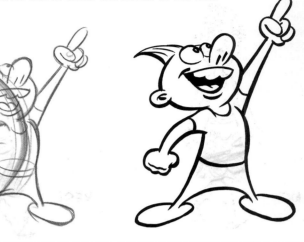

YES!

GOING NOWHERE

This little skateboarder looks like she's frozen in time—her pose is too straight, so there's no indication of movement whatsoever. Notice that the line of action is perpendicular to the ground.

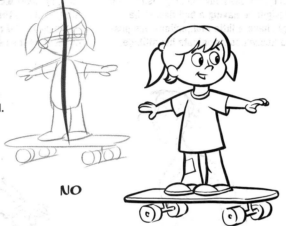

NO

MOVIN' AND SHAKIN'

But in this version, she looks like she's surfing down the sidewalk because her line of action has dynamic curves and rhythm!

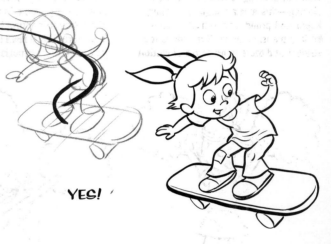

YES!

ANGLIN' FOR ACTION

The more curved and angled the line of action is, the more dynamic your character's pose will be! Study these examples to see how the line of action affects a character's appearance.

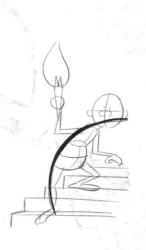

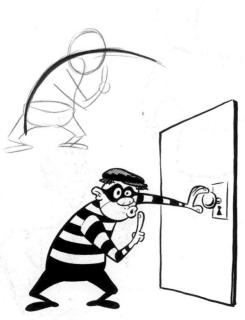

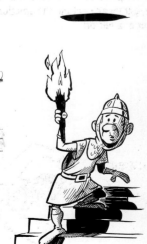

BODY LANGUAGE

You've already seen the way the face can express a multitude of different emotions and attitudes, but the rest of a character's body can be just as expressive. To give your character a bold attitude, apply what you've learned about line of action, facial expression, and proportion to the entire body. When trying to convey a certain emotion or attitude in your characters, remember to exaggerate—you have the freedom to make your characters as zany as you want, so get creative and ham it up!

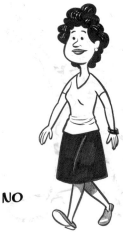

NO

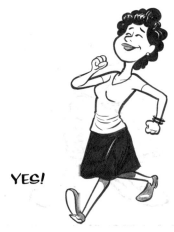

YES!

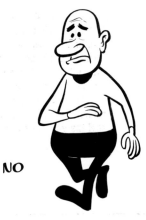

NO

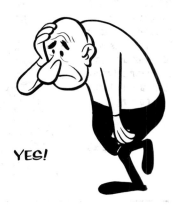

YES!

This stiff drawing is weak and unconvincing—this woman might be feeling happy and proud, or she might simply be in a pleasant mood. Her body is too straight and there is no sense of motion.

But this drawing communicates much more clearly. There is no ambiguity about how this young lady is feeling—she's strutting around looking like she just got a big promotion at work!

This guy's facial expression "reads" misery, but his body language isn't clear: He might be having a bad day, or he might have a little indigestion—his posture doesn't communicate his attitude.

Now this forward-curving body and low-hanging head tell us that this guy is definitely down in the dumps. Notice that his drooping line of action is the exact opposite of the happy young woman's.

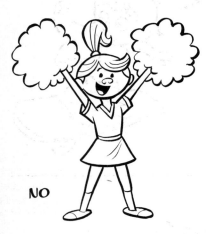

NO

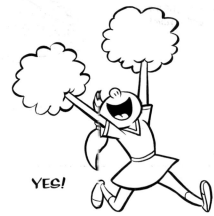

YES!

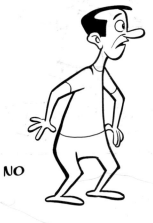

NO

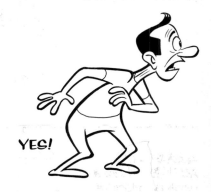

YES!

This cheerleader's face seems peppy enough, but her motionless body communicates that the football game has come to a standstill.

Putting the whole body in action—including the thrown-back head and extended arms—shows just how far an attitude can be pushed!

This guy looks a little startled, but his posture still doesn't give away very much—he could be scared silly, or he could have just heard a strange sound.

Now with a gaping mouth and crouched legs, he looks like he's just seen a ghost! His whole body is communicating the emotions of shock and awe.

ACTING OUT Before you set your pencil to paper, think about the emotion you're trying to express. Think about how your own body would look and feel if you were experiencing that emotion. Better yet, get up and act out the emotion in front of a mirror!

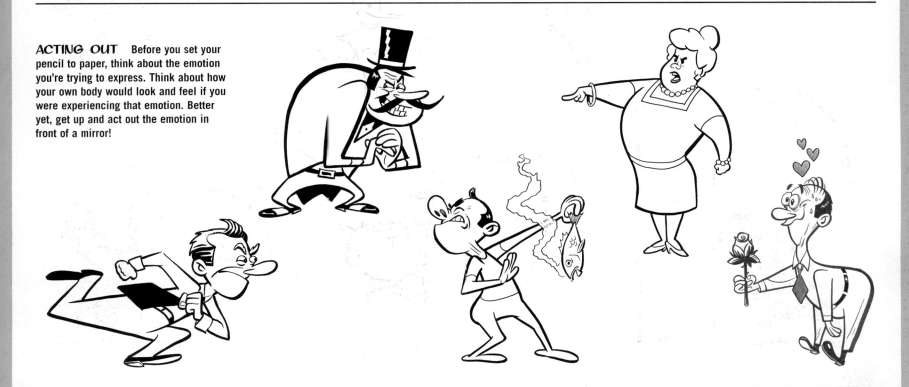

DRESS 'EM UP

Costume is a very important part of character design—clothing helps define and identify your character and tell its story. Costume includes not only clothing, but accessories and hair styles as well. Costume can help identify a character's occupation—police uniforms, chef's hats, football helmets, and farmer's overalls are some obvious choices. Accessories, such as a movie star's oversized sunglasses or a sheriff's star-shaped badge, can also indicate a character's identity and personality at a glance.

CHANGING APPAREL These four drawings all share the same body and face, but each costume creates a new character. A reader will react quite differently to a character dressed as a policeman than one dressed as a crook! Find those elements that really identify your character (for example, the policeman's badge, cap, and baton) and emphasize those elements until the character's role reads clearly and can be instantly identified.

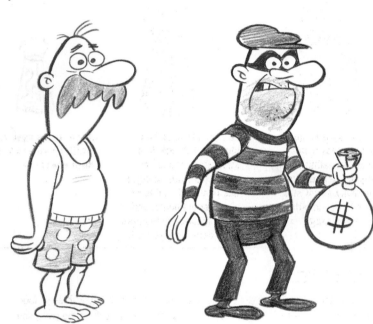
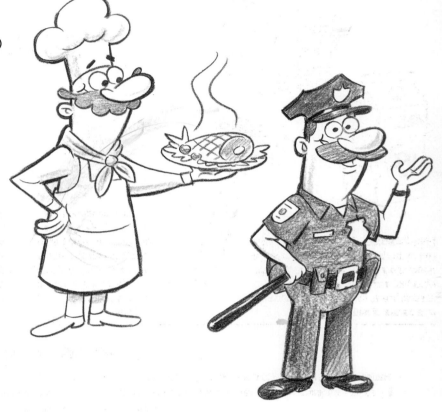

KEEPING THE FORMS When costuming your characters, always keep in mind the roundness and construction of the underlying forms, such as the egg-shaped torso and head and the cylindrical legs seen here.

IDENTIFYING A CHARACTER Remember that a costume doesn't have to be unique or exotic; anything that identifies a character can be a costume, such as this man's ill-fitting shirt, dinky tie, and huge, comblike mustache.

FOLLOWING THE LINES Be sure that the lines of the costume follow the shape and form of the body underneath. The slight bulge in the stomach rounds out this character's form, giving him a soft, pudgy look.

FLATTENING THE LINES If you don't round out the forms of the costume, you'll get flat, unrealistic lines—this character seems to recede into the paper rather than "pop" off the page.

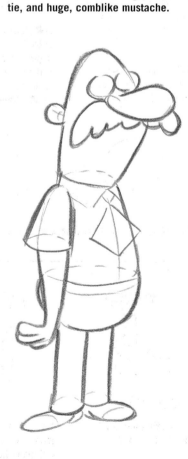
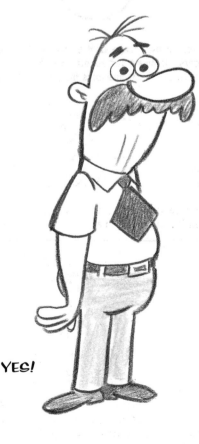

YES!

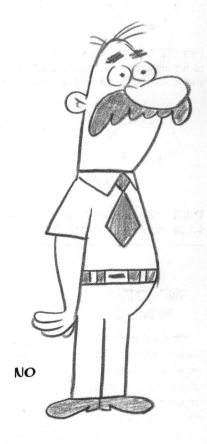

NO

GIVE 'EM PROPS

A prop is anything that a cartoon character uses to perform an action, like a salt shaker, a hammer, or a baseball bat. Unlike accessories, props are generally objects that the character holds rather than wears. The use of props helps further define your character as well as communicate the action being performed. For instance, if your character is bullying another character, you might add a hammer or an anvil to the bully's hand. When drawing props, always use some sort of reference. Don't just try to draw a prop from memory; if you get it wrong, it can look pretty funky!

SIMPLIFY AND EXAGGERATE

It's more important for your props to communicate clearly than it is for them to be modern or detailed. The two-edged principle of "simplify and exaggerate" applies to props as well as to characters!

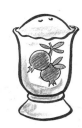 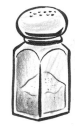 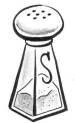 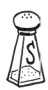

PREPARING TO DRAW Before you try to draw any prop, make sure you really know what it looks like. You can often find examples of the items you need at home, like a book, a hammer, or a carton of milk.

The salt shaker on my dinner table looks like this, but I wouldn't draw a salt shaker like this in a cartoon—it just doesn't identify as a salt shaker clearly or quickly enough.

This example is more like the classic salt shaker, something that everyone can recognize right away. But it still needs to be simplified and exaggerated!

Few people have salt shakers that look like this, but it "reads" as a salt shaker right away. It has been reduced to its simplest elements, and those distinctive features have been exaggerated.

If your props need to be small, be sure to simplify them even more.

HANDS-ON EXPERIENCE

Hands can be very difficult to draw, but they'll look better (and will be easier to draw) if you keep them simple. The cartoon hand can be drawn with either three or four fingers plus a thumb. If your character is more cartoony, the three-fingered hand will probably look great—but if a character is more on the realistic side of the scale, you should use a four-fingered hand to avoid distracting your audience.

 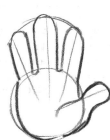 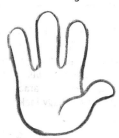 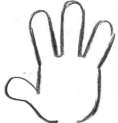 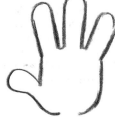

FRONT VIEW All hands start with a simple circle or oval shape for the palm, with an arc to indicate the spread of the fingers. The fingers and thumb radiate out from the center of the palm; the palm has a crease where the base of the thumb joins the palm.

BACK-HANDED The crease can't be seen on the back of the hand.

VARYING THE SHAPE Hands vary in shape just as much as bodies do. The hand on the left is a pretty average hand; the hand in the middle would fit well on a tall, skinny character; and the hand on the right belongs to a tiny character.

BACK VIEW Here's the back of the hand from a more common angle. Make sure the tips of the fingers always align in an arc rather than in a straight line.

SIDE VIEW And here's the side of the palm in a more common view.

HOLDING HANDS

When a character is holding a prop, you will usually want your reader's attention focused on the object rather than on the hand. So keep the hands simple and functional in order to keep the emphasis on the prop.

 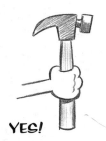 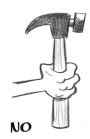 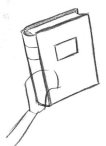 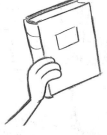

It's a good idea to draw your prop before the hand. After the prop is roughed in, indicate the hand with a simple ball.

YES! When a hand grips a handle, try to wrap the hand around the object.

NO Avoid putting too much detail on the hand!

When a hand holds a flat object like a book, you don't need to draw the thumb on the far side. When the thumb and index finger are holding a small object, start by roughing in a simple claw shape. Tuck the middle finger and pinkie into the palm to keep it simple.

YOU'VE GOT MALES!

As you probably know by now, there are many differences between men and women. And these differences in facial and body construction also translate into cartooning! Generally men have broader shoulders and thicker necks than women do; their waists are about the same thickness as their hips; and their feet are usually fairly large. Men also often sport mustaches, beards, or "five-o'clock shadows."

MEN'S BODY CONSTRUCTION

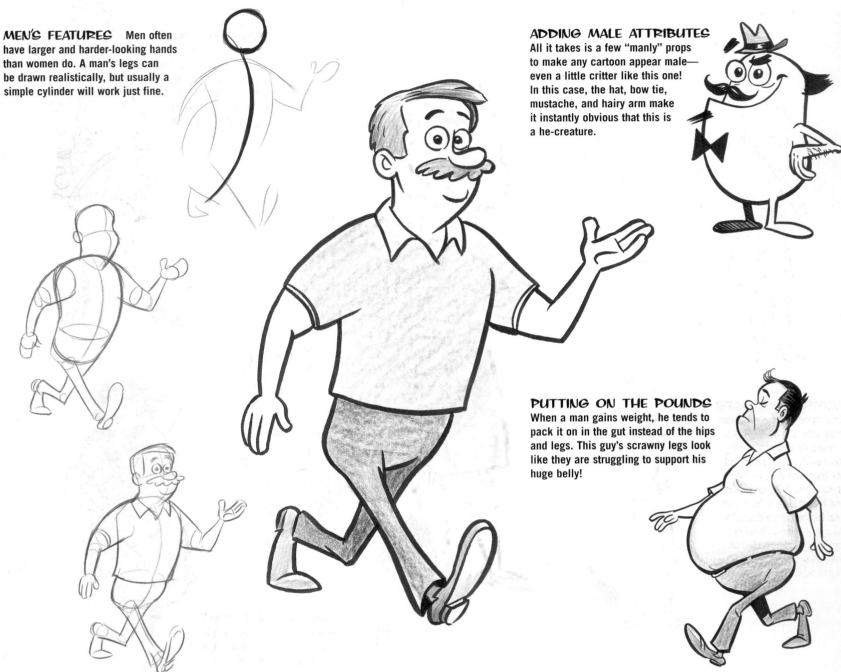

MEN'S FEATURES Men often have larger and harder-looking hands than women do. A man's legs can be drawn realistically, but usually a simple cylinder will work just fine.

ADDING MALE ATTRIBUTES All it takes is a few "manly" props to make any cartoon appear male—even a little critter like this one! In this case, the hat, bow tie, mustache, and hairy arm make it instantly obvious that this is a he-creature.

PUTTING ON THE POUNDS When a man gains weight, he tends to pack it on in the gut instead of the hips and legs. This guy's scrawny legs look like they are struggling to support his huge belly!

CHISELED FEATURES A man's facial features are usually stronger and more angular than a woman's are. The jaw is square, the nose is large, and the neck is thick.

BIGGER FOREHEADS Men's hairlines tend to start farther back on the scalp than women's do.

THINNING ON TOP Most men start to lose some hair by their 30s. Some men lose hair from the front; others start to go bald at the top of the head.

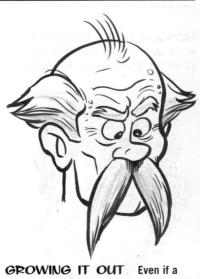

GROWING IT OUT Even if a man is bald and gray, he can still grow a mustache or a beard.

LADIES' NIGHT

Women wear many of the same clothes as men do, but they can also wear dresses and skirts in many different styles. Women are fun to draw because you have the freedom to accessorize—add some elegant jewelry, subtle makeup, pretty hair ribbons, funky shoes, or fashionable handbags. Also remember that women's legs are drawn more realistically than men's are—use a simplified cylinder that narrows at the ankle.

WOMEN'S BODY CONSTRUCTION

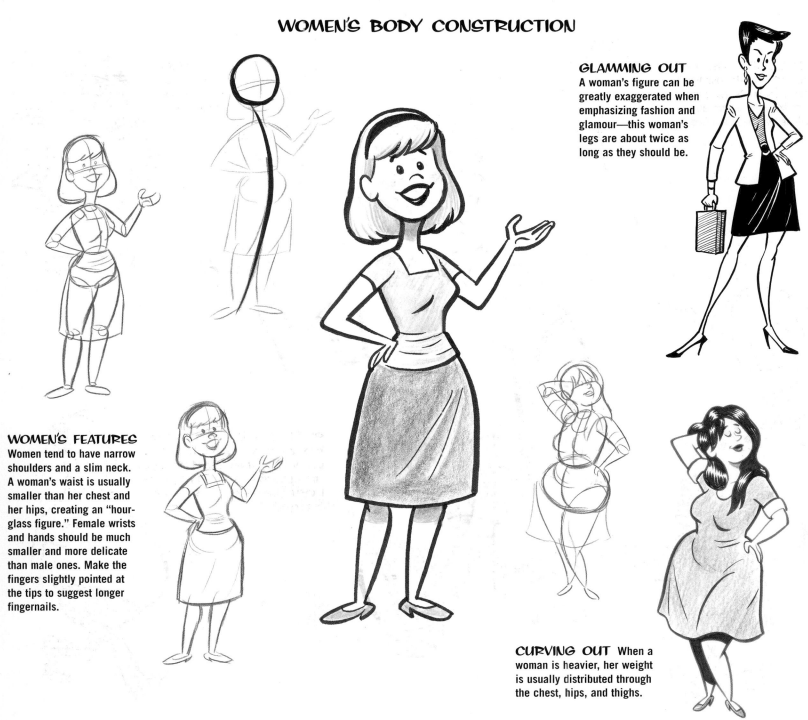

GLAMMING OUT
A woman's figure can be greatly exaggerated when emphasizing fashion and glamour—this woman's legs are about twice as long as they should be.

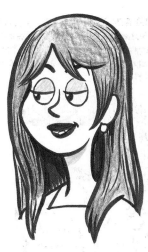

WOMEN'S FEATURES
Women tend to have narrow shoulders and a slim neck. A woman's waist is usually smaller than her chest and her hips, creating an "hour-glass figure." Female wrists and hands should be much smaller and more delicate than male ones. Make the fingers slightly pointed at the tips to suggest longer fingernails.

CURVING OUT When a woman is heavier, her weight is usually distributed through the chest, hips, and thighs.

VARYING HAIR Women's hair styles can vary more than men's do. Try giving your female short, curly locks.

BATTING EYES Long, curled eyelashes can be very important to a woman's makeup routine.

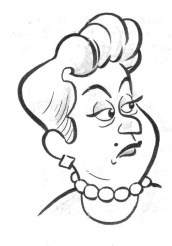

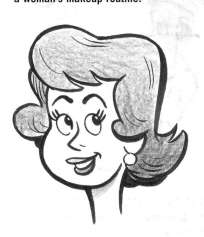

GETTING OLDER More mature women usually have shorter, closely cropped hair; or their hair can be twisted into a bun.

FEMINIZING THE FACE Long hair, shaded eyelids, darker lip color, and jewelry can all add to the femininity of a face.

KIDDING AROUND

From crybabies and spoiled brats to bullies and sulky teens, kids offer an endless array of fun personalities to draw. For younger kids, draw big heads, wide eyes, small bodies, and pudgy limbs—and keep everything simple and round. For teens, elongate the bodies and limbs a bit, but keep the features round and youthful. You can also add clothing and accessories that indicate youthfulness, like ribbons and bows, toys, ice cream cones, and more! Kids are more relaxed and uninhibited in their actions and expressions, so let go of your own inhibitions when drawing them.

BABY FACE Babies don't have very much hair, but they sure have gigantic foreheads! Their pupils are usually very large as well, and their eyes are spaced far apart.

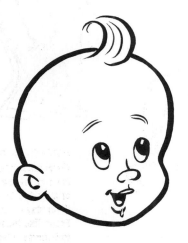

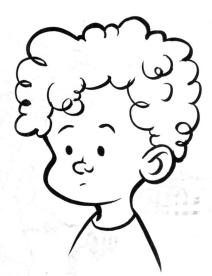

GROWING UP As a child ages, his or her hair starts growing in thicker and longer. The neck also elongates, and the eyes appear a bit closer together.

ADDING EXTRAS Little girls can have ponytails, pigtails, and various clips and bows in their hair to suggest their young age. Try adding freckles and a few missing teeth to make your character look younger.

SHORT AND SWEET Babies' bodies are about 2 heads tall. Dress up babies in diapers or jumpers, and equip them with appropriate props, such as rattles, pacifiers, or bottles.

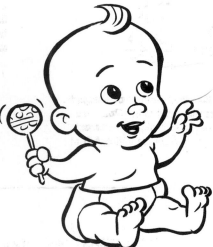

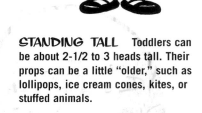

STANDING TALL Toddlers can be about 2-1/2 to 3 heads tall. Their props can be a little "older," such as lollipops, ice cream cones, kites, or stuffed animals.

AWKWARD PHASE Teenagers sprout up quickly, so draw them on the lean and lanky side. This teen's pants are a little too short because he's been growing so fast. Props like headphones and video games are great for helping to identify a teenager.

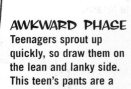

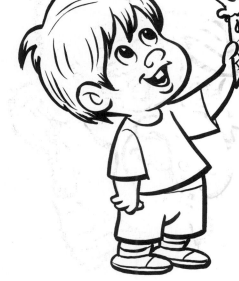

BIGGER IS BETTER When adding props to kid characters, draw them bigger than you normally would. Drawing the prop—like this ice cream cone—bigger than the child makes the kid seem small in comparison.

GROW UP!

As adults get older—or long in the tooth, as some say—many physical changes take place. Their clothing and accessories change, as well—try giving your older character a pair of thick glasses, a cane or walker, or some knitting needles.

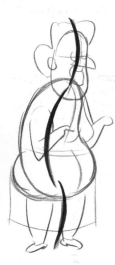

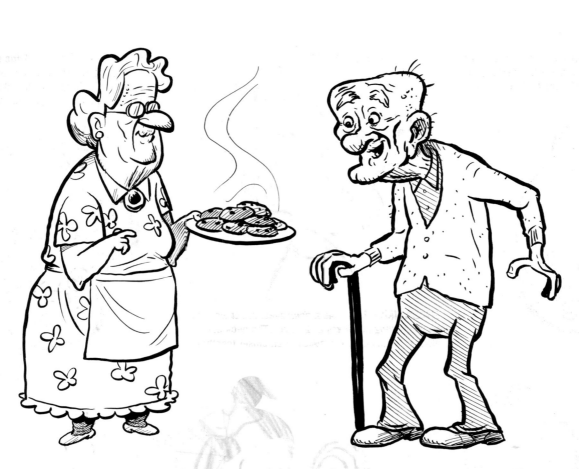

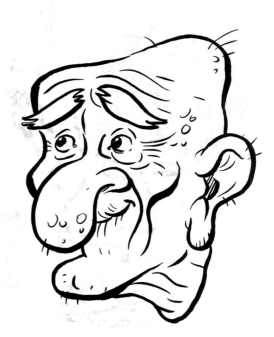

SHRINKING WITH AGE Older people actually start to shrink because their backs are curving with age. Notice the curved lines of action that places the head forward but arches the back a bit.

AGE-OLD PROPS Many older people also have to rely on a cane or a walker to help them stay on their feet. Props like these start to become integrated into the body structure because they begin acting as limbs. The line of action curves inward here to show the slouched posture.

COSTUMES AND PROPS Older men and women tend to dress differently than their younger counterparts. Their clothes often seem baggy and loose because the characters are not as robust as they used to be. Older men may also have tufts of hair sprouting from their chin, head, or ears. Adding elements like granny glasses, a brooch, or an old-fashioned dress also helps emphasize the age of a character. Some "older" props might be a plate full of steaming cookies, a ball of yarn, or a deck of playing cards.

THE AGING PROCESS

MIDDLE AGE By their 40s, both men and women start to lose the elasticity in the skin, which causes wrinkles and baggy skin to appear. In men, the chin and jowls start to fill out a bit more, and the hairline begins to recede.

EVEN OLDER AGE When adults reach an elderly state of being, their noses and ears gradually become bigger. Really old folks' cheeks often look hollow because their teeth have fallen out!

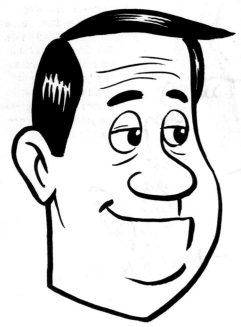

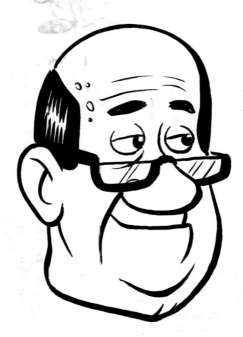

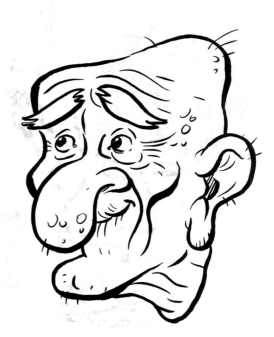

OLDER AGE As people continue to age, wrinkles become more prominent. Age spots may appear around the temples and on the hands. Glasses or hearing aids become more common as eyesight and hearing begin to worsen.

FORGET ME NOT

When it comes to the main characters of a cartoon, it's important to make them distinct, noticeable, and memorable. You can do this by exaggerating the features and by adding distinguishable clothing, accessories, and hair styles. Try drawing your character in silhouette—if you can tell a lot about a character without any detail, you know you're getting it right!

STANDING OUT IN A CROWD Use what you've learned about exaggerating features and adding distinctive clothing and accessories to make your main character stick out like a sore thumb. Also, imagine what your character would look like in silhouette, and be sure to draw those elements that would make him or her most recognizable.

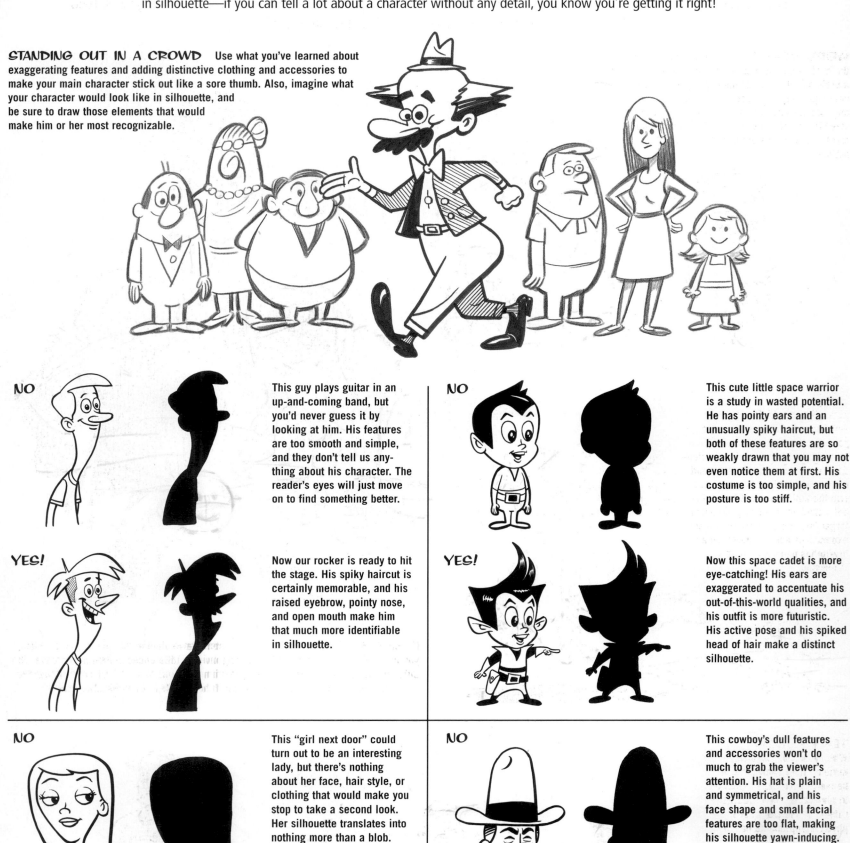

NO

This guy plays guitar in an up-and-coming band, but you'd never guess it by looking at him. His features are too smooth and simple, and they don't tell us anything about his character. The reader's eyes will just move on to find something better.

YES!

Now our rocker is ready to hit the stage. His spiky haircut is certainly memorable, and his raised eyebrow, pointy nose, and open mouth make him that much more identifiable in silhouette.

NO

This cute little space warrior is a study in wasted potential. He has pointy ears and an unusually spiky haircut, but both of these features are so weakly drawn that you may not even notice them at first. His costume is too simple, and his posture is too stiff.

YES!

Now this space cadet is more eye-catching! His ears are exaggerated to accentuate his out-of-this-world qualities, and his outfit is more futuristic. His active pose and his spiked head of hair make a distinct silhouette.

NO

This "girl next door" could turn out to be an interesting lady, but there's nothing about her face, hair style, or clothing that would make you stop to take a second look. Her silhouette translates into nothing more than a blob.

YES!

With a triangular face, exaggerated eyes (including longer lashes and raised eyebrows), and a high-flying ponytail, this girl will turn a few more heads! Even her necklace and earring add to her newfound appeal.

NO

This cowboy's dull features and accessories won't do much to grab the viewer's attention. His hat is plain and symmetrical, and his face shape and small facial features are too flat, making his silhouette yawn-inducing.

YES!

Now *this* is one tough cowboy! His hat is even taller and has more character, and his nose and ear are larger. These additions alone tell us bootloads about how tough he is. And check out that crazy handlebar mustache!

OPPOSITES ATTRACT

There's no such thing as a one-man show in cartooning—all stories need at least two characters (or two sides to one character) to create conflict, which arises from differing goals or clashing personalities. And because you're telling a story with pictures, you should make these differences in your characters clear through their physical appearances and actions. Make sure that your audience never gets confused by characters that look too much alike!

WEIRD SCIENCE One of the oldest tricks in the book is pairing extreme opposites—for example, a brainiac scientist and his dopey younger brother who never quite grew up. Besides their physical differences, their actions and expressions also tell a story. The scientist's furrowed brow and stiff posture show that he disapproves of his brother's brainless actions.

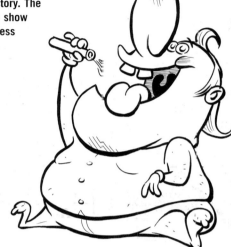

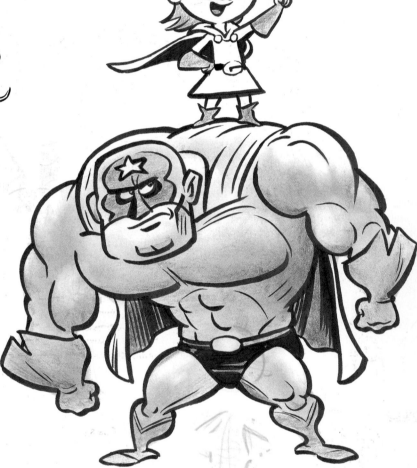

NATURE CALLS Another popular cartooning technique is pairing a predator with its prey. Some of the classic choices include dogs and cats, cats and mice, and hunters and rabbits. You can also turn the tables, as seen here—the baby chicken is bullying the much larger fox. The differences in their expressions leave no question as to who has the upper hand in this scene.

FLYING HIGH Even when your characters have similar interests or personalities, you can still distinguish them by creating obvious differences in their appearance. The bulging muscles and grim, serious expression of the male superhero contrast with the small, slender features and playful smile of the female hero on his shoulders.

TEAM PLAYERS
When your story involves three or more characters, it becomes even more important to give each one a specific role—and the character's physical appearance has to reflect that role. The older, heavier ballplayer looks like he might not run as quickly as the broad-shouldered home-run hitter; the lanky, goofy country boy carries an atmosphere quite opposite the chiseled, professional-looking pitcher next to him; and this teensy bat girl in an oversized shirt stands out from the rest.

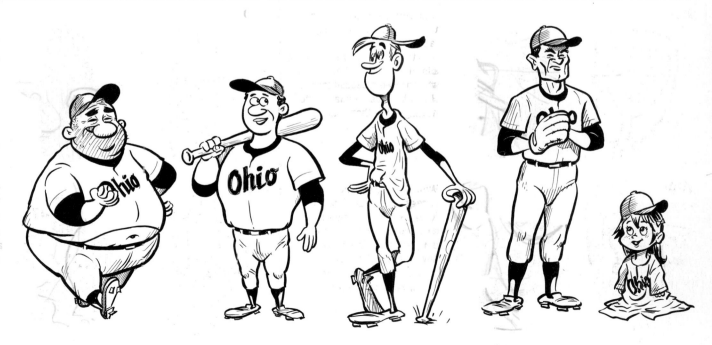

IT'S ALIVE!

From grizzly bears that drive cars and brush their teeth to sports cars that have a life of their own, cartoonists have been giving human qualities to animals and objects—called "anthropomorphism"—since the first cartoon was penned. To give human characteristics to a non-human thing, first imagine how the object or animal would look as a real person. Next identify the unique attributes of that animal or object, and imagine what the human would look like with those traits. Then combine the two, and you'll have a living, breathing cartoon character.

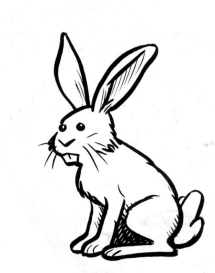

PICK A HUMAN, ANY HUMAN To create a cartoon animal, just start with an idea of a regular cartoon person.

CHOOSE CHARACTERISTICS Decide what kind of animal you'd like to create. In this case, it's a rabbit. Identify the attributes that make a rabbit look like a rabbit, such as long ears, fuzzy cheeks, buck-teeth, giant hind legs, and a cottony tail.

COMBINE CHARACTERISTICS Now just apply all those distinctive animal attributes to the human figure, and you have a new animal character with human traits! Replace human ears with oversized rabbit ears, draw giant rabbit legs instead of human legs, and so on.

COMPARING CONSTRUCTION
Imagining your animal cartoon as a human works because many animals have the same basic construction as humans do: a head at the top of the torso with two eyes, two ears, a nose, and a mouth; two front limbs; and two back limbs.

PICKING POSES Drawing your animals in poses that a human would be more likely to take—such as this crocodile's upright stance with his hand on his hip—creates a more realistically human character. And human actions—such as using a toothpick—help the effect even more.

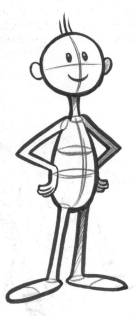

TURNING THE TABLES Many animals (such as insects and jellyfish) don't share the basic human construction at all. Rather than giving animal qualities to a humanlike figure, you can apply human characteristics (like the eyelashes and lips) to the animal.

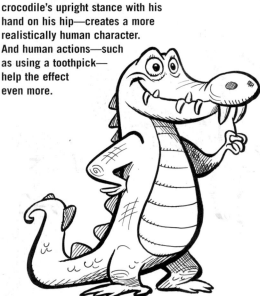

DRESSING UP
Keep in mind that props and costumes can be used with animals just as they are with humans. This solemn dog looks like he's heading out on the road for some hard traveling, and the hat and sunglasses give him a humanlike personality.

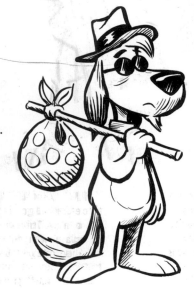

EXAGGERATING TRAITS Find the most prominent aspect of the animal you'd like to create and exaggerate it in your cartoon. For example, this lion's long, curling mane is the focus of the drawing. Adding a crown also shows the lion's royalty—after all, he is known as the "king of beasts."

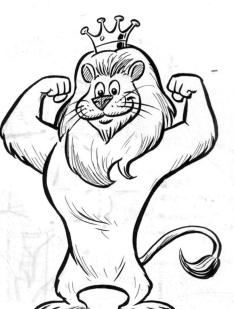

OBJECT-TION!

Inanimate objects—like cars, trees, toasters, and writing utensils—also make great cartoon characters, especially for use in advertising. (Advertisers love cartoons because they communicate so well!) When animating inanimate objects, imagine the object as a human figure, and then focus on the particular traits of the object—if it's a tree, think about the roots and branches and the way they can look like limbs; imagine the knots of a tree as eyes. Focus on the body shape first; arms and legs can be added later, as needed.

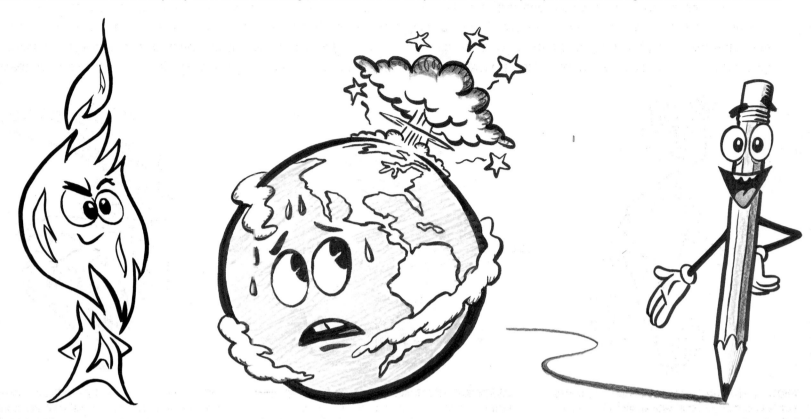

BLAZING TRAILS Even a flame can become a cartoon character if you give it a face and a little bit of attitude. You can also separate the flame so that it has a distinct head and body, as shown here.

EXPRESS YOURSELF Images like this planet being threatened by some disaster are very common in editorial cartoons. Because the planet is just floating in space, there's no need to add arms or legs—the beads of sweat and the worried expression are what give it human characteristics.

THE WRITE STUFF Here the pencil becomes the basic body shape. The eraser already looks like a little hat, so the face works well when drawn directly below it. Because the pencil is so thin, overlapping the eyes and mouth so they hang off of the body helps them show up better. You can add very simple arms and hands for gesturing, but feet are unnecessary because this pencil is standing on its tip.

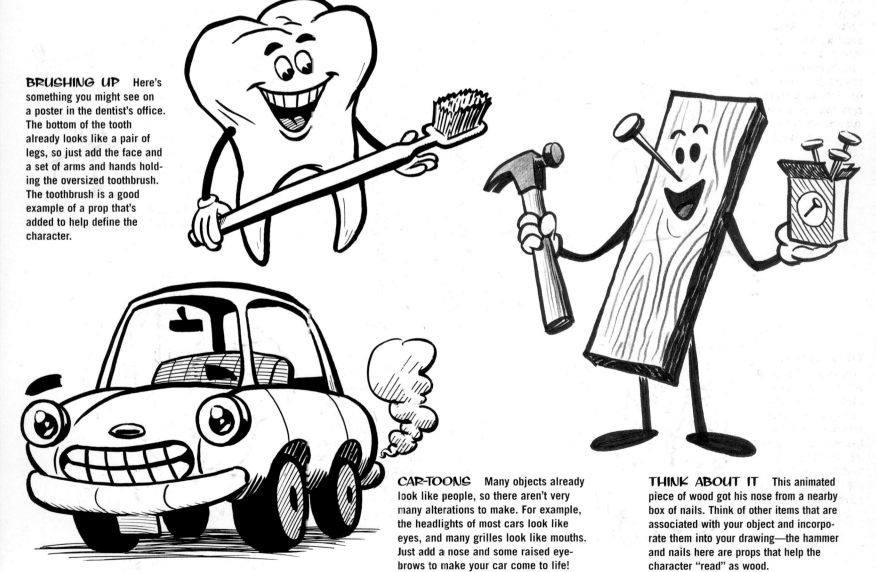

BRUSHING UP Here's something you might see on a poster in the dentist's office. The bottom of the tooth already looks like a pair of legs, so just add the face and a set of arms and hands holding the oversized toothbrush. The toothbrush is a good example of a prop that's added to help define the character.

CAR-TOONS Many objects already look like people, so there aren't very many alterations to make. For example, the headlights of most cars look like eyes, and many grilles look like mouths. Just add a nose and some raised eyebrows to make your car come to life!

THINK ABOUT IT This animated piece of wood got his nose from a nearby box of nails. Think of other items that are associated with your object and incorporate them into your drawing—the hammer and nails here are props that help the character "read" as wood.

GET GRAPHIC

Now that we've spent much of this book talking about the construction and roundness of forms, it's time to break all those rules! *Graphic* cartoon design (often referred to as "flat" style) puts more emphasis on interesting shapes than on roundness and depth. Although this style first emerged in the 1950s, it's still considered very modern. In fact, many of today's popular animated cartoons are based on these design principles. This approach is often the total opposite of the way we've been working so far; remember that one style is never "better" than the other—it's merely a matter of preference and using the best style for the specific project.

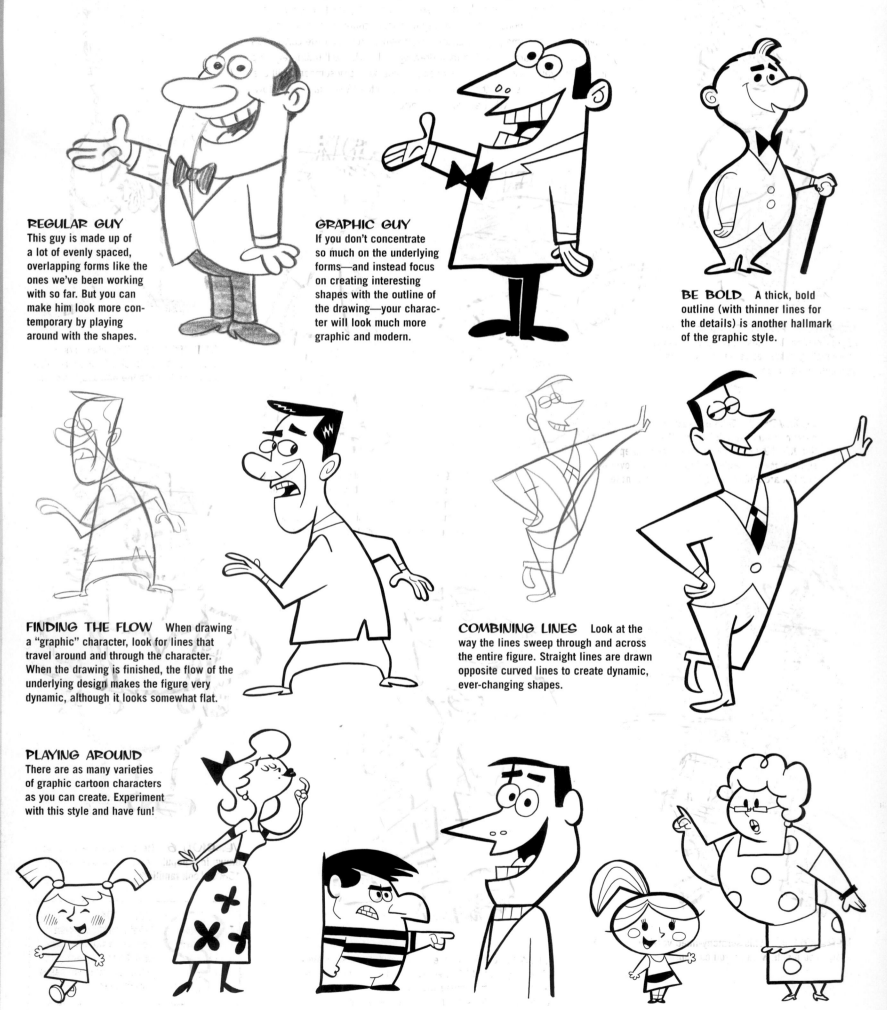

REGULAR GUY
This guy is made up of a lot of evenly spaced, overlapping forms like the ones we've been working with so far. But you can make him look more contemporary by playing around with the shapes.

GRAPHIC GUY
If you don't concentrate so much on the underlying forms—and instead focus on creating interesting shapes with the outline of the drawing—your character will look much more graphic and modern.

BE BOLD A thick, bold outline (with thinner lines for the details) is another hallmark of the graphic style.

FINDING THE FLOW When drawing a "graphic" character, look for lines that travel around and through the character. When the drawing is finished, the flow of the underlying design makes the figure very dynamic, although it looks somewhat flat.

COMBINING LINES Look at the way the lines sweep through and across the entire figure. Straight lines are drawn opposite curved lines to create dynamic, ever-changing shapes.

PLAYING AROUND
There are as many varieties of graphic cartoon characters as you can create. Experiment with this style and have fun!

FIND YOUR OWN STYLE

Every cartoonist has his or her own style that is as personal and unique as a fingerprint or a snowflake. It's a good idea to expose yourself to many different styles of cartooning so you can see how many different ways there are to design a character. The best thing to do is just keep drawing what you like—your style will develop naturally. Always remember that there is no "right" or "wrong" way to draw; if it looks good, draw it!

EXPERIMENTING WITH STYLE

To illustrate the wide variety of styles there are to work with, start by drawing a character of your own choosing; then portray that same character in a range of different styles. Think of some popular characters drawn by your favorite cartoonists and try to create your characters using their drawing styles. This will ultimately help you come up with your own signature style; and maybe someday someone will use your unique "voice" to assist in the creation their characters! The examples below will help you get started.

STARTING POINT Draw a character of your choice, like this pudgy guy, and add some distinguishing accessories, such as suspenders and a hat.

VERSION 1 Take the same basic character and adapt it into another style, like this 1930s-esque cartoon. Try to keep some of the elements similar—here the overalls and hat are still present, but in a different form.

VERSION 2 Keep changing the character, using some of your favorite styles as a guide. Now this character has a more modern, "alternative cartoon" design. The overalls have been replaced, but the hat remains.

VERSION 3 This character is drawn in the style of a 1950s magazine cartoonist—note the flat, graphic style!

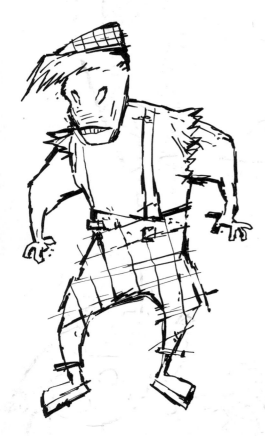

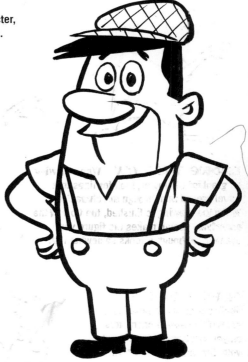

VERSION 4 This scratchy-lined version shows you just how much you can push it!

VERSION 5 This example employs the "rubber hose" style of old-fashioned animation, where characters seemed to move without regard to anatomy, as if their limbs were made of rubber hoses.

VERSION 6 Here's the same character drawn in a popular cartooning style of the 1960s. Look familiar?

VERSION 7 What would your own version of the character look like? Why not grab a pencil and some paper and find out?

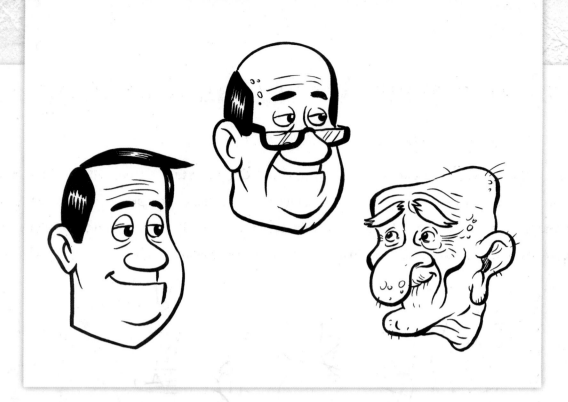

About the Artist

Sherm Cohen grew up in Los Angeles, California, where he spent his childhood drawing cartoons in the margins of his schoolwork. After studying cartooning at the Joe Kubert School of Cartoon and Graphic Art in Dover, New Jersey, Sherm drew cartoons and other illustrations for Los Angeles Pierce College's weekly newspaper and for many national and local magazines. These experiences helped Sherm get his first job in the animation industry as a character layout artist on *The Ren & Stimpy Show*™. Sherm went on to write, direct, and draw storyboards for many television shows, including *Hey Arnold*™ and *SpongeBob SquarePants*®, at Nickelodeon Animation Studios. He has also created storyboards for Warner Bros. Feature Animation and Cartoon Network Studios. Sherm's work reached the big screen when he served as the lead storyboard artist and character designer for Nickelodeon's 2004 hit feature film *The SpongeBob SquarePants Movie*. In addition to writing and drawing comics and children's books, Sherm has illustrated several comic stories that have appeared in *Nickelodeon Magazine*. In 2008 and 2009, Sherm created storyboards for Disney's *Phineas and Ferb,* and he is currently working on its new Sunday morning cartoon, *Kick Buttowski: Suburban Daredevil.*